THE CHRISTMAS STORY

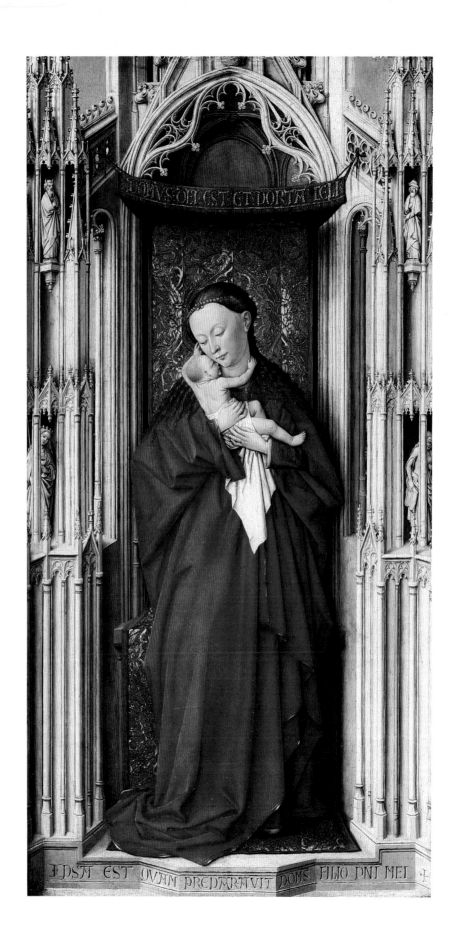

THE CHRISTMAS STORY

told through paintings

With commentary by

RICHARD MÜHLBERGER

The Metropolitan Museum of Art

NEW YORK

Gulliver Books

Harcourt Brace Jovanovich, Publishers

SAN DIEGO NEW YORK LONDON

JACKET: Details from *The Adoration of the Shepherds*,
 Marcellus Coffermans, Flemish, active between 1549
 and 1570. Tempera and oil on wood, 8⅛ × 5½ in.

PAGE 2: *Virgin and Child*. Style of Jan van Eyck, Flemish,
 third quarter of the 15th century. Tempera and oil
 on wood, 23 × 12⅛ in.

Extracts from the Authorized Version of the Bible (The King James
Bible), the rights of which are vested in the Crown, are reproduced
by permission of the Crown's patentee, Cambridge University Press.

Published by The Metropolitan Museum of Art, New York, and
Harcourt Brace Jovanovich, Publishers, San Diego

LIBRARY OF CONGRESS CATALOGING-IN-PUBLICATION DATA

The Christmas story: told through paintings/with commentary by
Richard Mühlberger; the Metropolitan Museum of Art.—1st ed.
 p. cm.
 "Gulliver books."
 ISBN 0-87099-602-9 (MMA)
 ISBN 0-15-200426-2 (HBJ)
 1. Jesus Christ—Nativity—Art. 2. Painting, Renaissance.
I. Mühlberger, Richard. II. Metropolitan Museum of Art
(New York, N.Y.)
ND1430.C47 1990
755'.53'09409024—dc20 90—4774

Produced by the Department of Special Publications,
The Metropolitan Museum of Art
Photography by
The Metropolitan Museum of Art Photograph Studio
Printed and bound by A. Mondadori, Verona, Italy
Designed by Peter Oldenburg

B C D E

PREFACE

Year after year for centuries, people have heard and read the Christmas story. Today it is told in songs and pageants, in churches and in store windows, and on greeting cards and in the pages of magazines. This book records the telling of this famous tale by painters who lived hundreds of years ago in Italy or Flanders during the period of history called the Renaissance. These paintings, all from the collections of The Metropolitan Museum of Art in New York City, may seem familiar, even the ones by artists whose names you do not recognize, because they have endured for generations. They are as popular today as they were when the artists first made them, for no images have been more powerful in forming the way others envision the miracle of Bethlehem than these and others of the same era.

Through the centuries, the recounting of the Nativity of Jesus has never changed. The setting may vary from a simple cave to the ruins of a castle, and the costumes may range from plain frocks to elaborate vestments. The faces and the reactions of the people in the story take on subtle differences with each retelling, bringing freshness and sometimes even gusto to the beloved tale. But the characters and the events are always the same, closely following the majestic words of Saint Matthew and Saint Luke.

It is a small company. There are always handsome angels and serious shepherds. The Wise Men are self-confident, often amazed, and invariably respectful. Mary, the mother, is silent and meditative, and her husband Joseph stands by, sometimes trying to be helpful but more often looking a little confused. The central character in the sweet drama, the baby Jesus, radiates light in some of the depictions and, in others, expresses intelligent curiosity or gentle love.

This book introduces you to varied interpretations of these characters, along with others who take part. As familiar as you may be with the Christmas story, through these paintings and the commentary that accompanies them you will come to know it anew.

RICHARD MÜHLBERGER

THERE was in the days of Herod, the king of Judaea, a certain priest named Zacharias, of the course of Abia: and his wife was of the daughters of Aaron, and her name was Elisabeth. And they were both righteous before God, walking in all the commandments and ordinances of the Lord blameless. And they had no child, because that Elisabeth was barren, and they both were now well stricken in years. And it came to pass, that while he executed the priest's office before God in the order of his course, according to the custom of the priest's office, his lot was to burn incense when he went into the temple of the Lord. And the whole multitude of the people were praying without at the time of incense. And there appeared unto him an angel of the Lord standing on the right side of the altar of incense. And when Zacharias saw him, he was troubled, and fear fell upon him. But the angel said unto him, Fear not, Zacharias: for thy prayer is heard; and thy wife Elisabeth shall bear thee a son, and thou shalt call his name John. And thou shalt have joy and gladness; and many shall rejoice at his birth. And Zacharias said unto the angel, Whereby shall I know this? for I am an old man, and my wife well stricken in years. And the angel answering said unto him, I am Gabriel, that stand in the presence of God; and am sent to speak unto thee, and to shew thee these glad tidings. And, behold, thou shalt be dumb, and not able to speak, until the day that these things shall be performed, because thou believest not my words, which shall be fulfilled in their season. And the people waited for Zacharias, and marvelled that he tarried so long in the temple. And when he came out, he could not speak unto them: and they perceived that he had seen a vision in the temple: for he beckoned unto them, and remained speechless. And it came to pass, that, as soon as the days of his ministration were accomplished, he departed to his own house. And after those days his wife Elisabeth conceived, and hid herself five months, saying, Thus hath the Lord dealt with me in the days wherein he looked on me, to take away my reproach among men.

The Angel Gabriel Announcing to Zacharias the Birth of a Son

Giovanni di Paolo, Italian (Sienese), active by 1417,
d. 1482

Tempera and gold on wood, 29⅞ × 14 in.

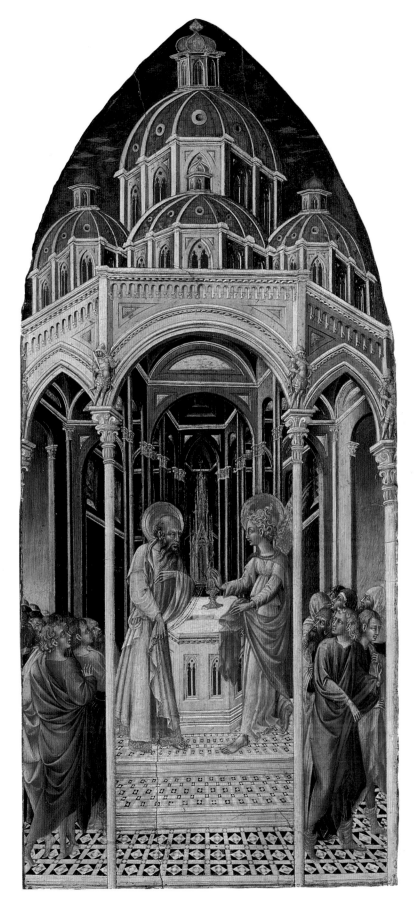

This tall and spindly painting was probably part of a shrine honoring Saint John the Baptist, whose father Zacharias is pictured with the angel Gabriel receiving the news of his elderly wife's pregnancy. After the Virgin Mary, Saint John is the most important Christian saint because he was the cousin of Jesus and announced Christ's coming. Saint John's life is the subject of more paintings than that of any other New Testament hero aside from Jesus and Mary.

Zacharias's job was to burn incense in the temple as an offering to God. He also protected the secret 2,000-year-old formula for making the incense and cared for all the implements used to prepare, store, and burn it. A gold censer for the last task stands on the altar, and Zacharias holds its chain in his right hand. The bottom half of the censer looks like a goblet and holds smoldering charcoal, over which the incense granules are sprinkled. The bottom is topped with a tall, fancy lid, which has holes in it that allow air to feed the charcoal fire when the censer is swung by the chain. The sweet-smelling smoke that escapes through the holes and rises to the heavens represents the prayers of the faithful.

Buildings with domes like the one shown here were a rare sight in fifteenth-century Italy. The artist Giovanni di Paolo knew of the construction of the largest dome in Europe atop the Cathedral in Florence, which was begun in 1426. He might have even met its famed architect, Brunelleschi, when Brunelleschi visited Siena in 1443. To symbolize the importance of Saint John's father Zacharias as a priest, the artist models the temple domes in his painting after those of the Florentine *Duomo* (the Italian word for cathedral), which was the marvel of all Christendom. Never mind that Giovanni's skinny columns could hardly support four domes and that his square floor is inexplicably covered by an octagonal roof! The building is only a stage set for this story of a very incredulous father-to-be.

Giovanni di Paolo includes more architecture, but in miniature, in his rendition of the temple tabernacle behind Gabriel and Zacharias. It has tall, pointed arches in the Gothic style, which was going out of fashion during Giovanni's lifetime. The temple itself has Gothic arches above the congregation of confused worshipers, but there is a rounded arch over the altar. Like the domes above, the round arch is in the style of the Renaissance, the name given to the period when Giovanni and Brunelleschi lived. Renaissance means rebirth. It was a time when ancient Roman styles, like the rounded arch and the dome, came into use again. It has been suggested that some artists used Gothic elements to represent the Old Testament and Renaissance ones to symbolize the coming of the New.

THE ANNUNCIATION
Robert Campin, Flemish, active by 1406, d. 1444
Central panel of a triptych in oil on wood, 25¼ × 24⅞ in.,
ca. 1425

And in the sixth month the angel Gabriel was sent from God unto a city of Galilee, named Nazareth, To a virgin espoused to a man whose name was Joseph, of the house of David; and the virgin's name was Mary. And the angel came in unto her, and said, Hail, thou that art highly favoured, the Lord is with thee: blessed art thou among women.

In the 1420s, Robert Campin painted a room that was so like those of his neighbors' living rooms in Tournai, the city where he worked, that any of them would have recognized it as modern and stylish. In this familiar setting, he allows his viewers to witness supernatural events that even the Virgin Mary, the woman in red, is not yet aware are happening.

First, the angel Gabriel appears out of nowhere to announce that Mary will give birth to the son of God. At the same time, seven rays of golden light pierce the round window behind Gabriel, bringing a tiny figure of Jesus into the room. He represents the child that will be born just nine months from the day pictured. And to remind viewers why Jesus came into the world, the artist has the child carrying a miniature cross, for he would die upon a cross thirty-three years later.

Robert Campin was the first artist ever to present this often-painted New Testament episode in a contemporary setting. By making everything in the painting look real, the miracle of Mary's conception became real for fifteenth-century viewers, for they could easily imagine that it was taking place the minute they saw it. After other artists began to know this painting, it became popular to portray Biblical scenes in real-life settings.

In real life, however, one cannot see the ceiling, floor, and three walls of a room at the same time. To do that would require turning one's head up, down, left, and right to see each segment in sequence. Robert Campin exaggerated the perspective of the room so that all of it we see can be seen at one glance. He also tilted the table top so the objects on it can easily be appreciated, and he includes every little detail in case anyone wants to examine them closely.

While the objects on the table are ordinary ones, they are also like the ones found on a church altar—a book from which the liturgy is read, flowers as an offering of beauty, and a candle to represent Christ, the Light of the World. Near a church altar there would be a place for the clergy to wash and dry their hands, so here, on the far wall, Robert Campin includes a pot for holding water and an immaculately clean towel.

While all of these things look normal for a house, they add a secondary meaning to the painting—that Mary's role in the birth of Jesus was an act of worship. She is likened to a priest. The presence of ordinary objects from everyday life in a sacred scene also elevates the importance of the objects themselves. After a pious man, woman, or child saw this painting, reflected on it, and went home, the same objects there might remind them of the Annunciation and the holiness of Mary.

8

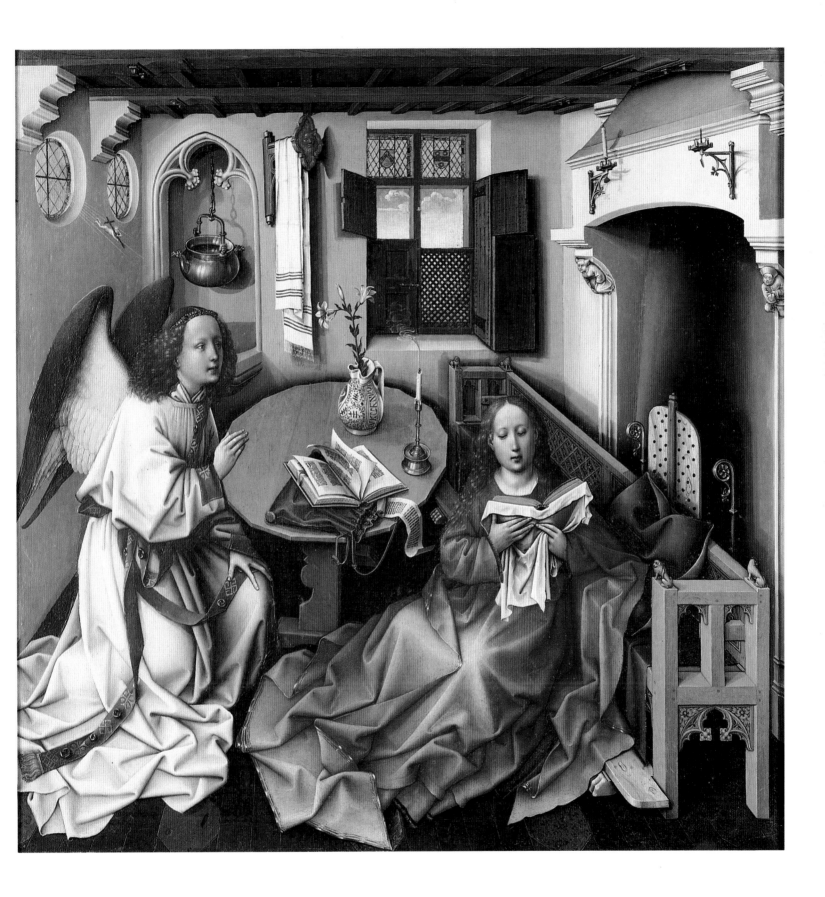

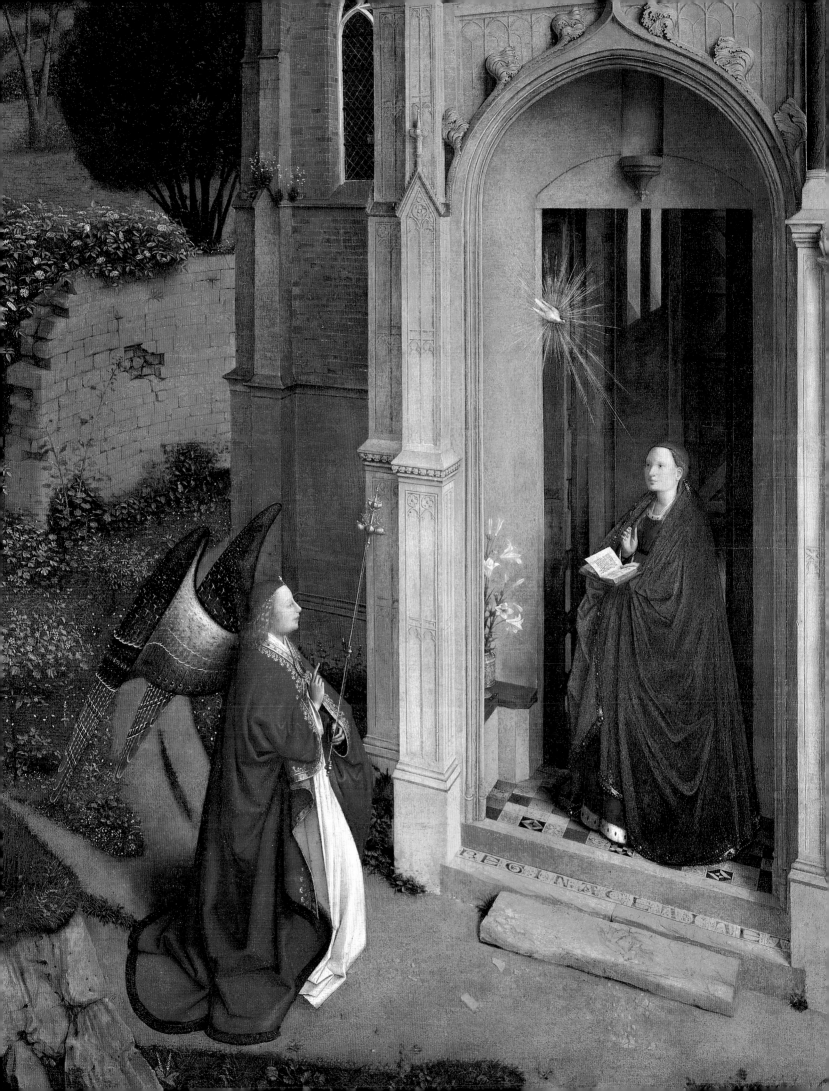

ND when she saw him, she was troubled at his saying, and cast in her mind what manner of salutation this should be. And the angel said unto her, Fear not, Mary: for thou hast found favour with God. And, behold, thou shalt conceive in thy womb, and bring forth a son, and shalt call his name JESUS. He shall be great, and shall be called the Son of the Highest: and the Lord God shall give unto him the throne of his father David: And he shall reign over the house of Jacob for ever; and of his kingdom there shall be no end. Then said Mary unto the angel, How shall this be, seeing I know not a man? And the angel answered and said unto her, The Holy Ghost shall come upon thee, and the power of the Highest shall overshadow thee: therefore also that holy thing which shall be born of thee shall be called the Son of God. And, behold, thy cousin Elisabeth, she hath also conceived a son in her old age: and this is the sixth month with her, who was called barren. For with God nothing shall be impossible. And Mary said, Behold the handmaid of the Lord; be it unto me according to thy word. And the angel departed from her.

THE ANNUNCIATION
Attributed to Jan van Eyck, Flemish, active by 1422, d. 1441
Tempera and oil on wood, 30½ × 25⅜ in.

What a privilege the artist has bestowed upon the viewer of this richly detailed painting! He allows an important sacred event to be seen from the vantage point of an angel, while he locates the angel Gabriel on a path where human beings ordinarily tread. And to emphasize that roles have been reversed, the Latin words meaning Queen of Heaven are engraved in the stone threshold at the Virgin Mary's feet. This exalted title is one of the many that were used from the Middle Ages on to honor the humble maiden of Nazareth.

Carrying the royal theme into her costume, the artist trims Mary's dress with ermine, that rare fur used in Europe to decorate the ceremonial garments of kings and queens. Its distinctive pattern can be seen where Mary's deep blue cloak opens at the top and bottom. Her outer garment is also fit for a queen, with its splendid border of jewels.

The imposing granite and brick building where Mary receives the angel is not a palace or castle. It is a church, and the well-worn rectangular stone that serves as a step indicates that many have come to this place to worship. Old legends about the Virgin Mary say that as a young girl she was dedicated to service and prayer in the temple. The artist painted a vase of pure white lilies inside the entrance to mark this building as Mary's adopted home. These are the flowers that, in art, represent her virginity. It was very unusual, by the way, to show this scene out of doors.

The carvings around the door have special significance. To the right of Mary, a monkey crouches at the top of a tall and narrow vertical molding. This animal frequently symbolizes sin in Christian art. The top of the rectangular column on the other side of the door is shaped like a lily, Mary's flower. Together the monkey and the lily mean that Mary will be instrumental in freeing the world from sin. Above Mary is an empty niche, a symbol for the place that Jesus will fill in God's plan of salvation. A more familiar symbol, the dove, circled by rays of light, flies above Mary's head. It represents the Holy Spirit.

It is thought that Jan van Eyck, the greatest artist of his day, painted this picture. Van Eyck usually collaborated with learned theologians as he planned the elaborate symbols that abound in his works. Many of these are hidden to modern eyes and probably were not even understood by most of the people of van Eyck's own day. The study of symbols and their meaning is called iconography. Understanding symbols enriches the appreciation of a painting, but van Eyck always included enough gorgeous detail to satisfy the eyes of anyone not initiated into this specialized science.

After one has explored the verdant plants scattered throughout the painting and examined the old brick wall and the red hollyhocks that grow against it, one's eyes always come back to the faces of Mary and Gabriel. No element of the painting, no matter how microscopically detailed or richly ornamented, detracts from them. In Mary's gesture and the expression on her face, the Bible narrative is told in a split second. She has accepted the will of God even before she can utter the question "How shall this be?" She seems in a spiritual trance as Gabriel explains what is going to happen. It is her simplicity and Gabriel's sincerity that make their faces so compelling.

THE VISITATION
Workshop of Rogier van der Weyden, Flemish, mid-15th century
Panel from an altarpiece in tempera and oil on wood, 33⅝ × 16⅝ in.

A ND Mary arose in those days, and went into the hill country with haste, into a city of Judah; And entered into the house of Zacharias, and saluted Elisabeth. And it came to pass, that, when Elisabeth heard the salutation of Mary, the babe leaped in her womb; and Elisabeth was filled with the Holy Ghost: And she spake out with a loud voice, and said, Blessed art thou among women, and blessed is the fruit of thy womb. And whence is this to me, that the mother of my Lord should come to me? For, lo, as soon as the voice of thy salutation sounded in mine ears, the babe leaped in my womb for joy. And blessed is she that believed: for there shall be a performance of those things which were told her from the Lord. And Mary said, My soul doth magnify the Lord, And my spirit hath rejoiced in God my Saviour. For he hath regarded the low estate of his handmaiden: for, behold, from henceforth all generations shall call me blessed. For he that is mighty hath done to me great things; and holy is his name. And his mercy is on them that fear him from generation to generation. He hath shewed strength with his arm; he hath scattered the proud in the imagination of their hearts. He hath put down the mighty from their seats, and exalted them of low degree. He hath filled the hungry with good things; and the rich he hath sent empty away. He hath holpen his servant Israel, in remembrance of his mercy; As he spake to our fathers, to Abraham, and to his seed for ever. And Mary abode with her about three months, and returned to her own house.

The path that wends down the hill meets another and becomes a circle like a little stage where these two serious women meet. The words they speak to greet each other have become famous, and today pious Christians repeat them daily, as they have for centuries, in the form of a prayer called the Ave Maria and a canticle named the Magnificat. But the women are silent at the moment shown here. Each one feels for the beating of a little heart and they are amazed at the miracles happening inside of them. The artist makes it clear that Elisabeth is carrying a child in her womb by showing the laces on the side of her red gown stretched to accommodate her swelling body. The only other person in this painting is old Zacharias who sits at the gate of a stately manor house.

It was traditional to treat this subject with great solemnity, befitting Mary's position as the woman God chose to bear his son and Elisabeth's advanced age and her status as the wife of a priest. It was also a tradition to show Elisabeth and Zacharias as wealthier than they probably were. In the fifteenth century, when this scene was painted, great homes like the one created here for Zacharias and Elisabeth were acquired mainly through inheritance. The artist put the manor house in the picture to symbolize the distinguished lineage of the expectant parents of John the Baptist. Their family trees went back to famous patriarchs of ancient Israel: Aaron, the brother of Moses, and Benjamin, the last son of Jacob and Rachel. The empty courtyard outside the mansion may symbolize Elisabeth's former barrenness.

This scene features a steep mountainside. Although the building atop it looks like a typical small Flemish castle, its mountainous location shows that it is in a place far from the Low Lands, as Flanders and Holland, its neighbor to the north, were called. Most Europeans in the fifteenth century had no idea at all what the geography of the Holy Land was really like. They must have believed that it was alpine, for so many artists showed it that way.

The tale the artist is telling took place about fourteen hundred years earlier than the styles of his mansion and of his women's costumes. The story was so well known by his contemporaries that he could use the architecture and fashions of his own day without confusing them. In fact, this probably made the quiet but joyful moment depicted all the more believable for those who saw it.

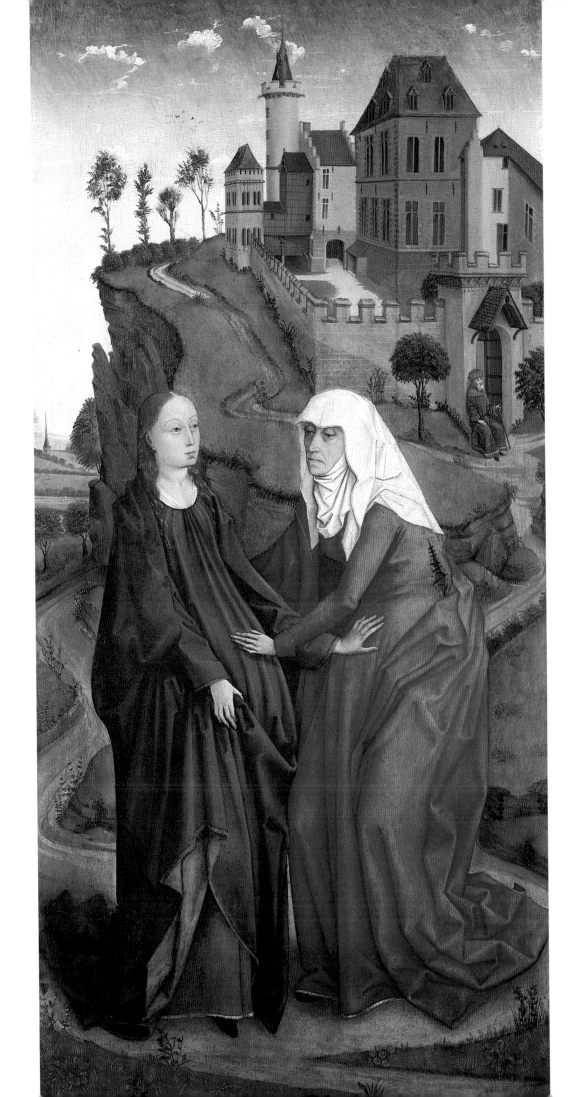

Now Elisabeth's full time came that she should be delivered; and she brought forth a son. And her neighbours and her cousins heard how the Lord had shewed great mercy upon her; and they rejoiced with her. And it came to pass, that on the eighth day they came to circumcise the child; and they called him Zacharias, after the name of his father. And his mother answered and said, Not so; but he shall be called John. And they said unto her, There is none of thy kindred that is called by this name. And they made signs to his father, how he would have him called. And he asked for a writing table, and wrote, saying, His name is John. And they marvelled all. And his mouth was opened immediately, and his tongue loosed, and he spake, and praised God.

SCENES FROM THE LIFE OF SAINT JOHN THE BAPTIST

Francesco Granacci, Italian (Florentine), 1469–1543
Oil on wood, 31½ × 60 in.

The Italian artist Granacci divides his scene into four segments, much like a modern-day comic strip. In each quarter of the painting, he depicts an episode from the story of the birth of Saint John the Baptist. Nine months pass between the scene on the left and the two on the right, but to eyes used to this kind of storytelling (something twentieth-century viewers have in common with those who lived five hundred years ago), a divider in the form of a column is sufficient to represent the passage of time. The columns and all the architecture in the painting are in the ancient Roman style that Granacci's contemporaries in Florence were reviving for their newest buildings.

14

On the far left, while Zacharias is at work in the temple, the angel Gabriel appears to him. The old man is surprised to hear that his prayers for a son will be answered, for his wife Elisabeth is well beyond childbearing age. The figure seated at the foot of the steps, with just a gray scarf as a covering, is a tribute to the famous artist Michelangelo, whom Granacci met when he was a student. It is probably modeled after ancient images representing river gods, and here it symbolizes the water that Saint John was to use in baptizing repentant sinners later in his life.

The second scene shows the visitation of Mary and Elisabeth. Next are the happy moments following the birth of John,

as he is passed from woman to admiring woman. In the final episode, Saint John's birth is announced to Zacharias.

So the viewer can see everything, Granacci opens the walls of the roomy mansion in which these events take place. The absence of exterior walls also enables him to show more of the landscape. It looks like the river Arno and the hills near Florence where Granacci lived, rather than Galilee of Biblical times. It seems a fine summer day, for the birth of John the Baptist was traditionally celebrated on the twenty-fourth of June. The fire that warms Zacharias would not be unusual in Italy in June, however, for homes there were chilly most of the year, and summer was often late in warming them.

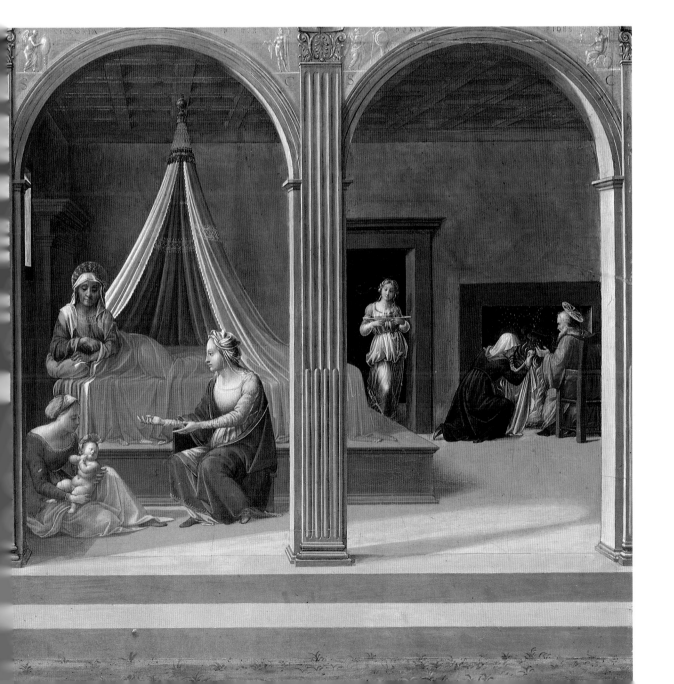

15

ND it came to pass in those days, that there went out a decree from Caesar Augustus, that all the world should be taxed. And all went to be taxed, every one into his own city. And Joseph also went up from Galilee, out of the city of Nazareth, into Judaea, unto the city of David, which is called Bethlehem; (because he was of the house and lineage of David:) To be taxed with Mary his espoused wife, being great with child.

THE ARRIVAL IN BETHLEHEM
Master LC, Flemish, active second quarter of the 16th century
Tempera and oil on wood, 26½ × 36⅞ in.

This scene looks like the setting for a fairy tale, and in Flanders in the early 1500s when it was painted, it was decidedly foreign looking. Jagged mountain pinnacles did not rise from the flat fields of Flanders the way they do in the middle of this painting. But Flemish towns did look like the one that represents Bethlehem here, and the Flemish landscape was dotted with windmills. There were even small castles built in the middle of rivers. The design of the one in the painting seems to imitate nature's peaks beyond it.

The name of the artist who painted *The Arrival in Bethlehem* is lost, but he is known by the initials LC, which he used to

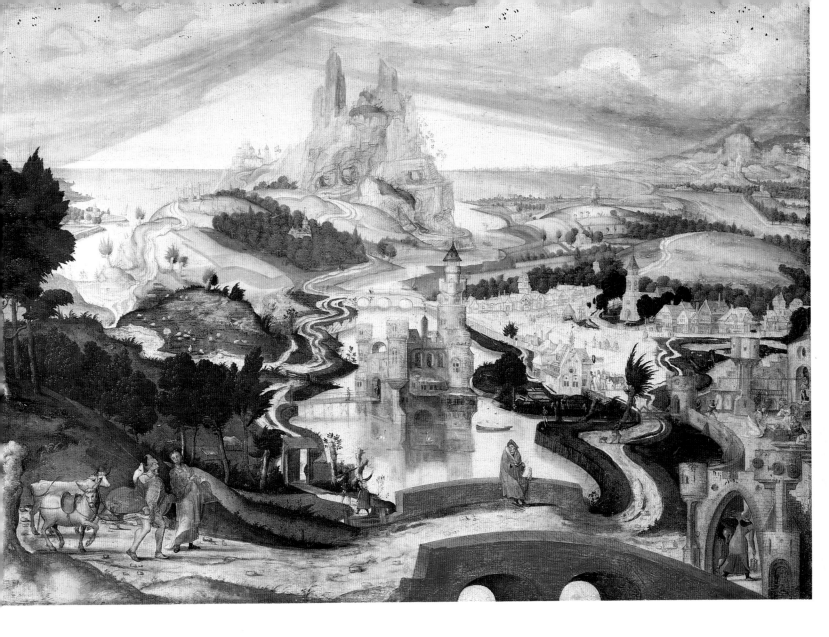

sign some of his works. When he put his delicate brush to this wood panel, using a modern setting for a Bible story was a relatively new idea. Telling it the way he does, however, was an old tradition in art. He scatters the story into different sections of the painting, with three scenes representing different episodes. To find them, follow the little dirt road through the landscape with Mary and Joseph. Start in the lower left corner.

The couple is approaching a rust-colored bridge where a man sits holding a book accompanied by his little white dog. He is watching the two travelers closely. Mary and Joseph are on the last leg of a ten-mile trek from Nazareth, where they lived, to Joseph's ancestral home of Bethlehem, where they have to register with the census takers and pay their taxes. Mary, who is nine months pregnant, must have become uncomfortable on the narrow saddle of the gray donkey. Although the Bible does not mention the two animals, old stories about the birth of Jesus always say the couple had a donkey and an ox as traveling companions.

Following the road along the river, the travelers reach the local inn. The recently laundered sheets and clothing that have been laid to dry on the back lawn are the only clue that a large number of wayfarers are staying there, leaving no room for Mary and Joseph. Turned away, they find a courtyard across from the inn, and that is where the child is born. Shepherds hurry in through a turret entrance to worship the newborn King, while their flocks graze on the hillside across the river from the castle.

Neither halos nor angels signify the holiness of the people and events recorded here. Perhaps they were to be added later, for Master LC abandoned this painting before it was finished. A close examination of the surface reveals sketchy pen-and-ink marks. Additional layers of pigment were to be added, which would have hidden them. But, to some, the painting is all the more valuable just the way it is. Its unfinished state reveals how sixteenth-century artists worked, creating a painting slowly, layer by layer.

Aᴺᴰ so it was, that, while they were there, the days were accomplished that she should be delivered. And she brought forth her firstborn son, and wrapped him in swaddling clothes, and laid him in a manger; because there was no room for them in the inn.

THE NATIVITY
Workshop of Fra Angelico (Guido di Pietro), Italian (Florentine), active by 1417, d. 1455
Tempera and gold on wood, 7⅞ × 17⅜ in.

If all the artists are correct in their depictions of the Nativity, Mary and Joseph did not have very much time alone with their new baby. There were almost always angels, shepherds, or Wise Men paying visits or just standing watch. Here a donkey and an ox wait nearby, ready to move closer if the child gets cold, for legends say these animals warmed Jesus with their breath. The angels, hovering above the roof, keep a polite distance as they echo the praise of the proud parents that God has come into the world as their little child.

This painting is by an assistant to Fra Angelico, a famous Dominican friar who was one of the most important artists of

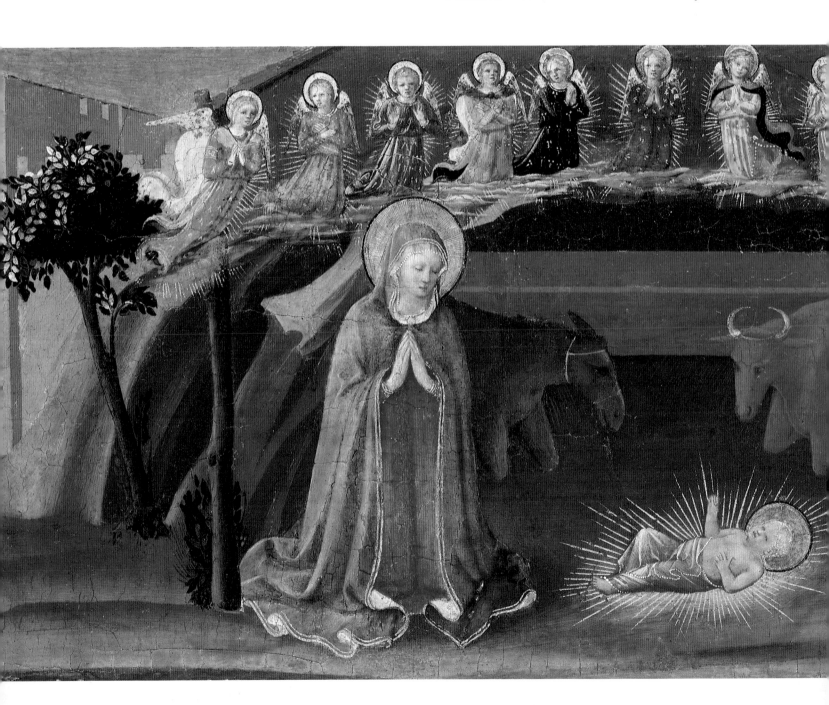

his day. Because of his great talent, he was much in demand as an artist and had to train assistants to help him with the many commissions that came his way.

In this version, the Nativity takes place at the mouth of a cave. Perhaps the artist knew the old and firm tradition that Christ was born in a cave on the edge of Bethlehem where cattle were kept at night. Behind this holy place, the walls of the town rise. The buildings on the left have been painted a surprising bright color, just as Fra Angelico might have done himself, and those on the right are in shades of gray.

Artists most often identify figures as holy by placing halos behind their heads. Sometimes they may also surround bodies with rays of light, called aureoles or glories. Fra Angelico's assistant uses both devices for the Christ Child and the angels. In ancient times, long before Christianity, the halo was used to identify deities, probably because its round shape resembles the sun. Like the sun, halos are always gold in color. The halos and aureoles in this painting are not just painted to look like gold, they are gold. Artists pounded the precious metal tissue thin, then glued it to paintings in narrow lines and in crescent shapes. The pounded metal is called gold leaf.

A ND there were in the same country shepherds abiding in the field, keeping watch over their flock by night. And, lo, the angel of the Lord came upon them, and the glory of the Lord shone round about them: and they were sore afraid. And the angel said unto them, Fear not: for, behold, I bring you good tidings of great joy, which shall be to all people. For unto you is born this day in the city of David a Saviour, which is Christ the Lord. And this shall be a sign unto you; Ye shall find the babe wrapped in swaddling clothes, lying in a manger.

ANNUNCIATION TO THE SHEPHERDS

Antoniazzo Romano (Antonio di Benedetto Aquilio), Italian (Roman), active by 1461, d. 1508
Detail from a painting, *The Nativity*, in tempera on wood, entire panel 11½ × 26½ in.

Antoniazzo Romano's angel is an unusual apparition, for it looms larger than the shepherd and has only half a body. But this does not frighten the shepherd who shields his eyes to see it better. He seems to be concentrating on the angel, who points the way to the manger where Jesus can be found. In fact, it is just on the other side of the stony outcropping, for this is a detail of a larger painting that shows Mary and Joseph worshipping the Christ Child.

Out of rocks and foliage Antoniazzo creates a protected shelter for the sheep and their friends, the brown goats. A stream passes through this little valley and some of the sheep head for it to drink. The shepherd carries his own supply of water slung under his left arm. The faithful sheep dog, lying on the ground next to the shepherd, is, like the shepherd himself, curious about the kind creature above them. The other animals take no notice, suggesting that the angel's message is a quiet one.

In art it is unusual to see a single shepherd in this episode of the Christmas story, since the Bible refers to shepherds. This thoughtful and dignified man, while representing the shepherds of Christmas Eve, might also prefigure the New Testament's symbolic images of Jesus as the Good Shepherd. One of the verses about the Good Shepherd says that he will separate the sheep, who represent saintly people, from the goats, who represent sinners. That may be why Antoniazzo Romano has included the goats with his flock. The shepherd might also represent all the people who hear the good news of Jesus's birth for the first time. There is even the possibility that the artist attached no symbolism to him at all. But one of the most satisfying experiences in looking at paintings is to try to figure out these things when something is different from the ordinary. In doing so, perhaps you will arrive at a private interpretation that no one else has ever thought of!

Antoniazzo Romano was the most prominent local painter in Rome, a city that attracted many gifted artists who were commissioned to add decorations to the Vatican for each new Pope. While Antoniazzo was able to see all the current styles that were brought to Rome and sometimes was influenced by them, he painted this scene in the conservative way that Roman painters for years preferred. They liked their figures solid and simple and their colors muted and earthy.

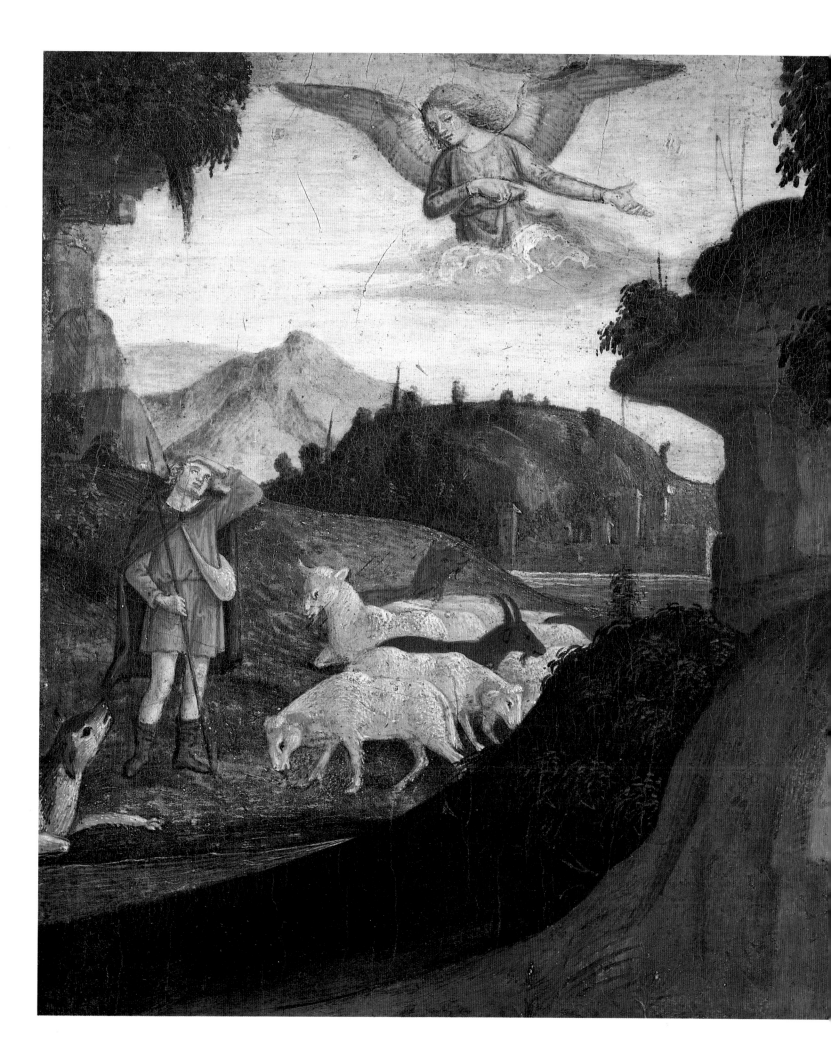

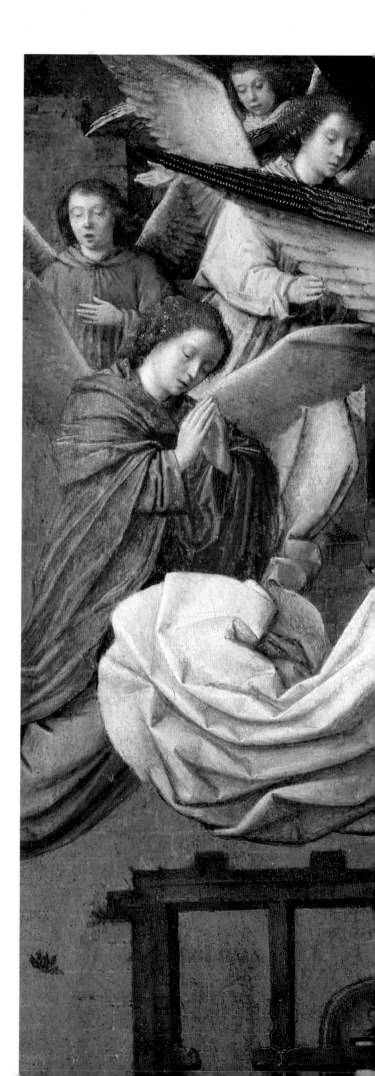

AND suddenly there was with the angel a multitude of the heavenly host praising God, and saying, Glory to God in the highest, and on earth peace, good will toward men.

ANGELS

Gerard David, Flemish, active by 1484, d. 1523

Detail from the central panel of a painting, *The Nativity*, in tempera and oil on canvas, transferred from wood, central panel 35¼ × 28 in.

Since ancient times, artists have painted human beings with wings to represent heavenly personages. In the Christian era, this tradition continued in the portrayal of angels. During the great age of discovery that is called the Renaissance (about 1400 to 1525) artists tried to outdo one another in making these winged youths look as though they were really airborne. Gerard David, the artist who painted these angels, was successful using a few simple devices.

The wings of his seven angels are in various flying positions. The ones toward the back are upward, while the next two pairs, closer to the viewer, are slightly more open. The foreground angels extend their wings as far as they can go. The overall impression is like a stop-action photograph. The viewer takes it for granted that each pair of wings will quietly assume all of the flight positions shown, suspending the angels in their worshipful positions.

To further the illusion of flight, the artist shows the action of air currents on the sashes and robes of his heavenly army. The fabric flies up and billows out, which seems to help keep this serious troop aloft. These garments, by the way, are called surplices and were the ordinary garb for priests and deacons during services of worship. Gerard David has tinted them iridescent pink and various shades of blue to match the angels' gold-tipped wings, but an ordinary surplice is white.

Although the Bible states that after the angels announced the birth of Christ, they left the shepherds and returned to heaven, popular devotional books of the period had them stay to serenade the newborn Jesus. In Gerard David's painting, the shepherds are within hearing distance of the angels' beating wings and the song of their voices. Familiar with these sounds from their earlier encounter with the heavenly host, the shepherds are led by this ethereal symphony to the Holy Child.

22

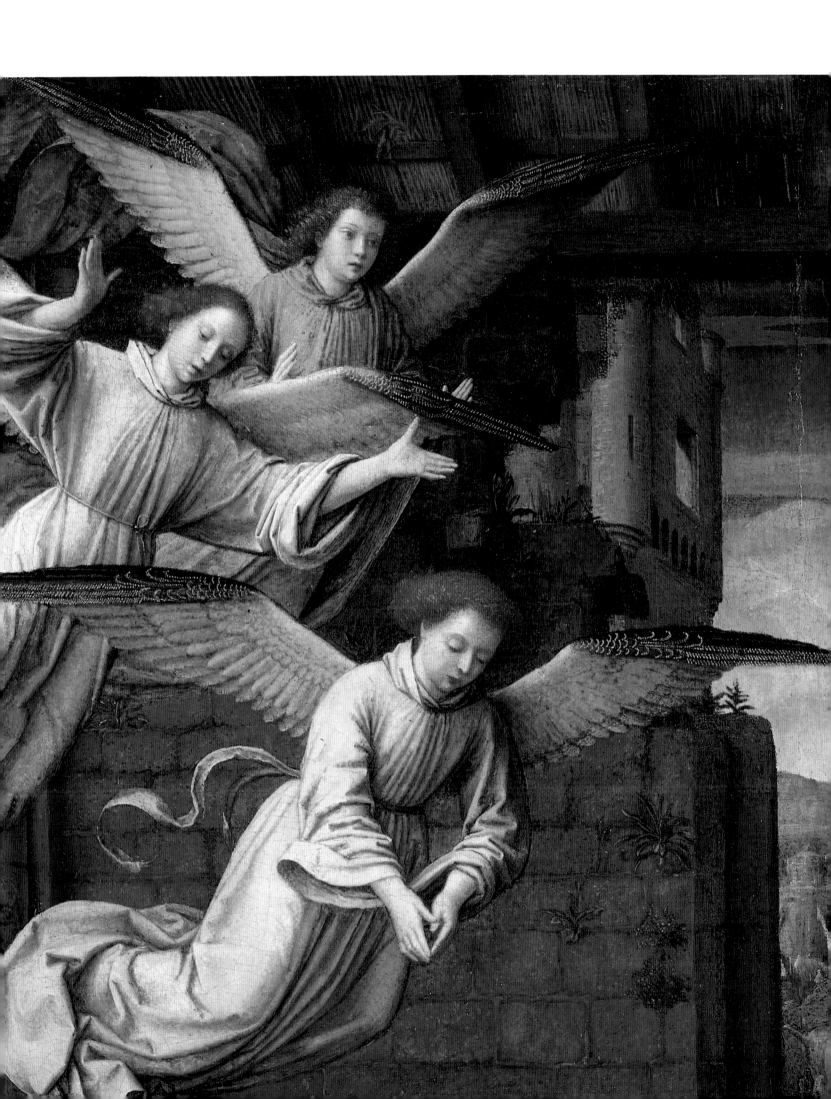

ND it came to pass, as the angels were gone away from them into heaven, the shepherds said one to another, Let us now go even unto Bethlehem, and see this thing which is come to pass, which the Lord hath made known unto us. And they came with haste, and found Mary, and Joseph, and the babe lying in a manger. And when they had seen it, they made known abroad the saying which was told them concerning this child. And all they that heard it wondered at those things which were told them by the shepherds. But Mary kept all these things, and pondered them in her heart. And the shepherds returned, glorifying and praising God for all the things that they had heard and seen, as it was told unto them.

THE ADORATION OF THE SHEPHERDS
Andrea Mantegna, Italian (Paduan), ca. 1430–1506
Tempera on canvas, transferred from wood, 15¼ × 21⅞ in.

Andrea Mantegna, one of the most celebrated artists of the Italian Renaissance, takes the Bible quite literally when it says that the shepherds "came with haste" to see Jesus. Indeed, he gives them the appearance of being out of breath from hurrying. The Bible also said that the shepherds made their visitation after the angels had returned to heaven. But a close look at the figures on the brown mountain ridges that rise sharply on the right side of the painting reveals tiny angels there, still conversing with shepherds. In the painting they are so small that a magnifying glass is needed to get a good look at them.

The shepherds are looking at Joseph and not at the baby. Perhaps they are too timid to approach Mary and the Holy Child without the permission of Mary's husband. They might even be envious of Joseph's lovely yellow cloak and warm red robe, for one of them is barefoot and the other wears clothing tattered beyond repair. Joseph is deep in thought, perhaps meditating on the wondrous birth that has recently taken place or just plain confused by all the attention his new wife and baby are receiving. Or perhaps he is just taking a nap. At any rate, the shepherds await his greeting before they continue up the rocky slope to the child.

Andrea Mantegna was one of the first great masters of perspective, a mathematically exact way of making figures and objects smaller so they look further away. From his youth, he was also interested in painting tiny details that would make his works seem like authentic records of the Bible's events. Because he uses perspective and makes background details almost as precise as the ones in the foreground, it is easy to wander around in one of his landscapes, exploring all the little vignettes he has included. But in this painting, his use of the color red keeps bringing you back to the central figures in the story.

24

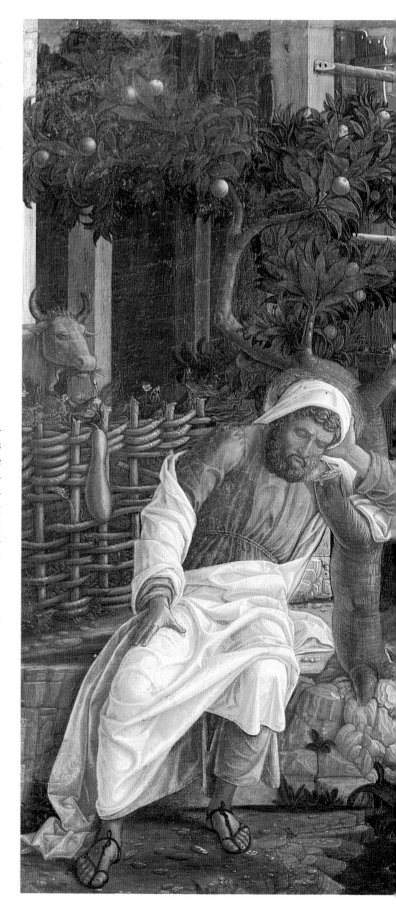

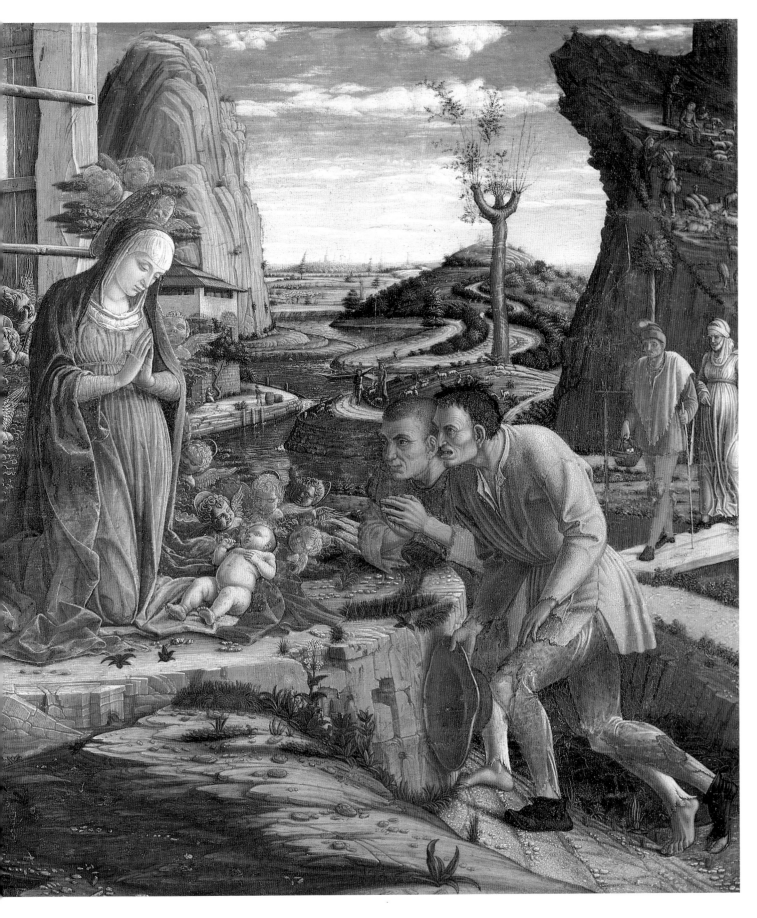

25

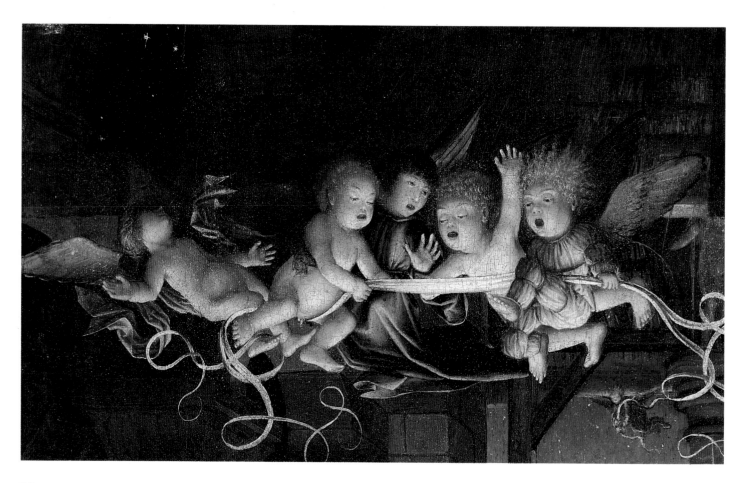

Nativity with the Annunciation to the Shepherds

Follower of Jan Joest, Flemish, active ca. 1515
Oil on wood, 41 × 28¼ in.

The theme of this early sixteenth-century Flemish painting is Jesus as the Light of the World. A symbol of this is the candle that Joseph shields from the drafts of night air that blow in from the open loggia behind the adoring angels. Throughout the Bible, Jesus is likened to light. He himself said, "I am come a light into the world, that whosoever believeth on me should not abide in darkness" (John 12:46). Here the artist interprets this literally and makes the body of Jesus the source of the illumination that brightens all of the faces circled around him and the little bodies of the rascal angels above.

These little angels yank garlands across the upper left side of the picture, and their lone partner to the right seems to be treading air in his attempt to catch up with the fun. They are singing at the top of their lungs. Their garlands direct attention to the scene outside the window. Musical shepherds peer in, one with a horn in his hand and the other ready to play his bagpipe. Their colleagues stand on a hill in the distance, shielding their eyes so they can see the angel who has come to announce the birth of Jesus to them.

This picture makes it clear that there are two kinds of angels in art, the serious adult ones and the playful children. The children derive from ancient mythology and its irreverent tales of Cupid, the son of Mars and Venus. They do not appear in Christian art until the Renaissance, the time when this work was painted. Perhaps artists incorporated them into sacred paintings to make the celebration of the birth of Jesus all the more approachable, for these cupids or putti (the Italian word for these little children in art) act like real children might.

Artists welcomed the opportunity to create night scenes, especially those that had only one source of light. This let them show how skillfully they could paint sharp contrasts of light and dark and how ably they could create wonderful iridescent effects. It also made possible such glowing passages as the hands and hair of the Virgin Mary. The radiance that reflects from the front of her white robe almost electrifies the golden strands that cascade from her head across her right arm. The same light emphasizes the elegant and tentative reach of her hands toward her baby.

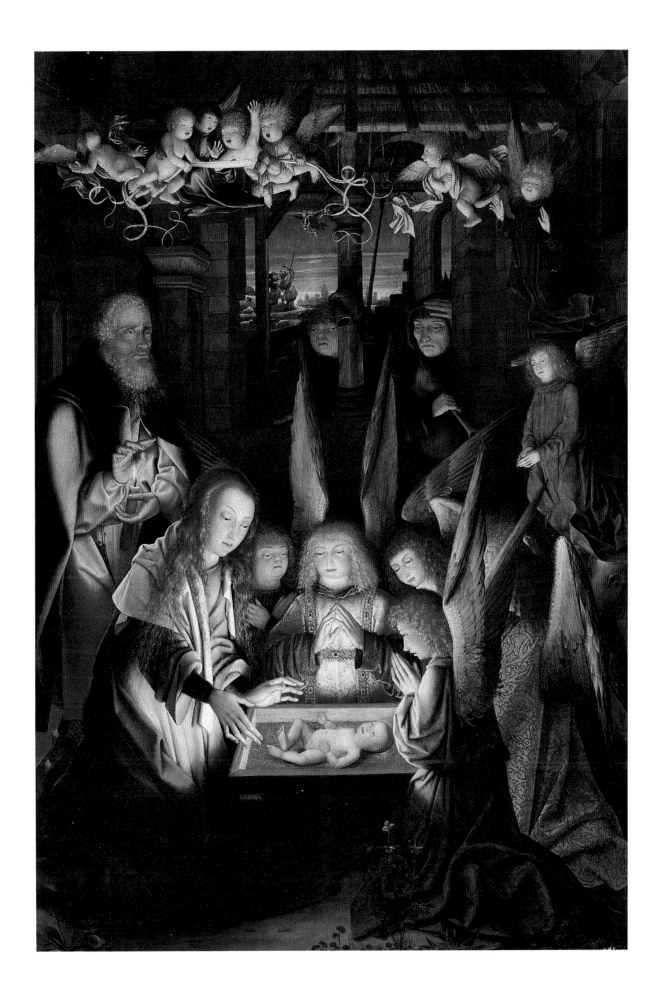

AND when eight days were accomplished for the circumcising of the child, his name was called JESUS, which was so named of the angel before he was conceived in the womb. And when the days of her purification according to the law of Moses were accomplished, they brought him to Jerusalem, to present him to the Lord; And to offer a sacrifice according to that which is said in the law of the Lord, A pair of turtledoves, or two young pigeons. And, behold, there was a man in Jerusalem, whose name was Simeon; and the same man was just and devout, waiting for the consolation of Israel: and the Holy Ghost was upon him. And it was revealed unto him by the Holy Ghost, that he should not see death, before he had seen the Lord's Christ. And he came by the Spirit into the temple: and when the parents brought in the child Jesus, to do for him after the custom of the law, Then took he him up in his arms, and blessed God, and said, Lord, now lettest thou thy servant depart in peace, according to thy word: For mine eyes have seen thy salvation, Which thou hast prepared before the face of all people; A light to lighten the Gentiles, and the glory of thy people Israel. And Joseph and his mother marvelled at those things which were spoken of him.

PRESENTATION IN THE TEMPLE
Master of the Linsky Presentation in the Temple, Italian (Pisan), active first third of the 15th century
Tempera and gold on wood, 13⅜ × 15⅞ in.

Art experts do not know who painted this picture. It is frustrating for them because they know a few other pictures by the same artist. Together with this one, they once were parts of an altarpiece. At some time, it was taken apart, and the pictures are now in various museums. From the appearance of the paintings, the experts guess that the artist lived and worked in Pisa, Italy, early in the 1400s and that the altarpiece was for a church or chapel there.

One might guess something else about the artist from studying the figures of Mary, Jesus, and Simeon. He was probably a family man, for he knew how babies react when their mothers hand them over to strangers with beards. Jesus reaches to Mary, not wanting to leave her embrace. But from the look on his face, Simeon will be very gentle with the child. He extends his arms to receive him. This is the high point of Simeon's life for he knows this little boy is the Messiah whom he has waited many years to see. The artist poses the child, slightly bowed, very much like the old man, uniting them in a visual way.

Artists also use color to pull parts of their compositions together. Here the similar shades of pink of Simeon's robe, the cloth wrapped around Jesus, and the wall in the background unite the line of figures in front of the wall together with Simeon and Jesus.

Behind Simeon are two altar boys, or acolytes. The older one probably had seen the pious old man often in the temple, and he seems to understand how important this moment is to him. The woman standing behind Mary and dressed in green is the old prophetess Anna. She is explaining to Joseph that the child will be the Redeemer. The scroll that streams from her left hand is a symbol of prophets in art and the indecipherable writing on it is the artist's idea of what Hebrew script looks like. A hand can be seen at Anna's right elbow. It belongs to the man behind Anna, who impatiently reaches back to hush the conversation, for Simeon is about to utter a prayer. It is called Nunc Dimittis, from the Latin translation of its opening words, and it has been part of the church's liturgy for centuries, repeated every evening in services called Vespers or Evening Prayer. So the scene when these words were first spoken is a fitting one to go over a church altar, as this panel originally did.

Like most of those done in the fifteenth century, this painting is on wood. The decorations on each golden halo are punched into the wood by a rolling tool. The artist himself probably did not do this, but hired a skilled artisan who made his living supplying ornamental "punch work" to other people's paintings.

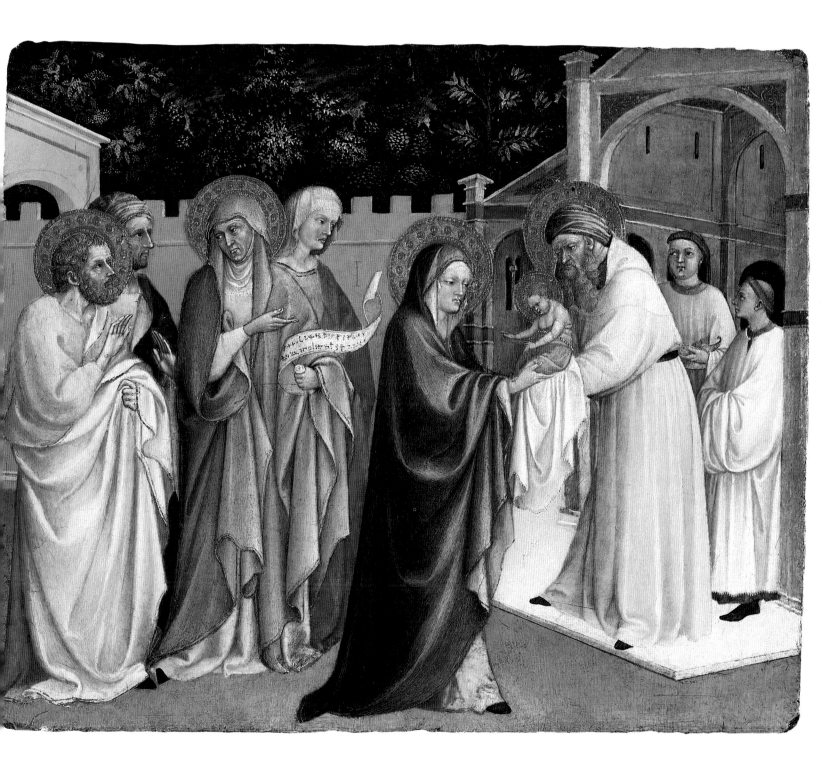

Now when Jesus was born in Bethlehem of Judaea in the days of Herod the king, behold, there came wise men from the east to Jerusalem, Saying, Where is he that is born King of the Jews? for we have seen his star in the east, and are come to worship him. When Herod the king had heard these things, he was troubled, and all Jerusalem with him. And when he had gathered all the chief priests and scribes of the people together, he demanded of them where Christ should be born. And they said unto him, In Bethlehem of Judaea: for thus it is written by the prophet, And thou Bethlehem, in the land of Juda, art not the least among the princes of Juda: for out of thee shall come a Governor, that shall rule my people Israel. Then Herod, when he had privily called the wise men, enquired of them diligently what time the star appeared. And he sent them to Bethlehem, and said, Go and search diligently for the young child; and when ye have found him, bring me word again, that I may come and worship him also. When they had heard the king, they departed; and, lo, the star, which they saw in the east, went before them, till it came and stood over where the young child was. When they saw the star, they rejoiced with exceeding great joy.

THE JOURNEY OF THE MAGI
Sassetta, Italian (Sienese), active by 1423, d. 1450
Tempera and gold on wood, 9⅜ × 12⅜ in.

X marks the spot where the Magi can be found in this painting. So that they stand out from the other fancy people in the long procession, Sassetta places them at the intersection of two slopes. A green one, barren like the hills near Siena in Italy where Sassetta lived, angles down from the upper left where two cranes feed. The gravel path on which the travelers are beginning to slide is the second imaginary line that forms the *X*. Beneath the Magi is a star, which also brings attention to their black, white, and bay horses and to their serious faces.

In fact, the Magi are almost at their destination, the birthplace of the infant King. Originally, it was shown in a lower section of this painting, which was sawed off years ago and is preserved

today in Siena. It pictures the Magi worshipping Jesus as the Virgin Mary and Saint Joseph look on. When the artist first painted the picture, the star was directly over the Christ Child, who sat on his mother's lap in front of a wall. In bisecting the painting, a very narrow strip from the top of that wall was left at the bottom of *The Journey of the Magi*, so it is easy to imagine how the two scenes worked together.

"Wise men," the Bible called them, or Magi, a word referring to the priestly magicians of Persia. Sassetta probably thought they were teachers and philosophers, as many scholars do today, for he pictures them deep in conversation. Another tradition said that they were kings from the Orient. But no one knows exactly who they were or where they came from. It is not even known that there were three of them. That simple bit of mathematics is based on the gifts they brought to the baby Jesus —frankincense, gold, and myrrh.

Sassetta does not picture the traditional gifts. They are probably under the wraps on the backs of the two pack horses at the front of the procession. He invented a wonderful but unlikely new gift, however, as his own contribution to the story of the Magi. It is the monkey enjoying the ride on his very own blue-gray donkey. Christian art often pictures the monkey as a symbol of sin and lust or as the devil in disguise. But to Sassetta, a monkey would be the perfect plaything for a young prince. And, after all, the Magi do not know yet that the King of the Jews they will soon visit was not a king in the usual sense.

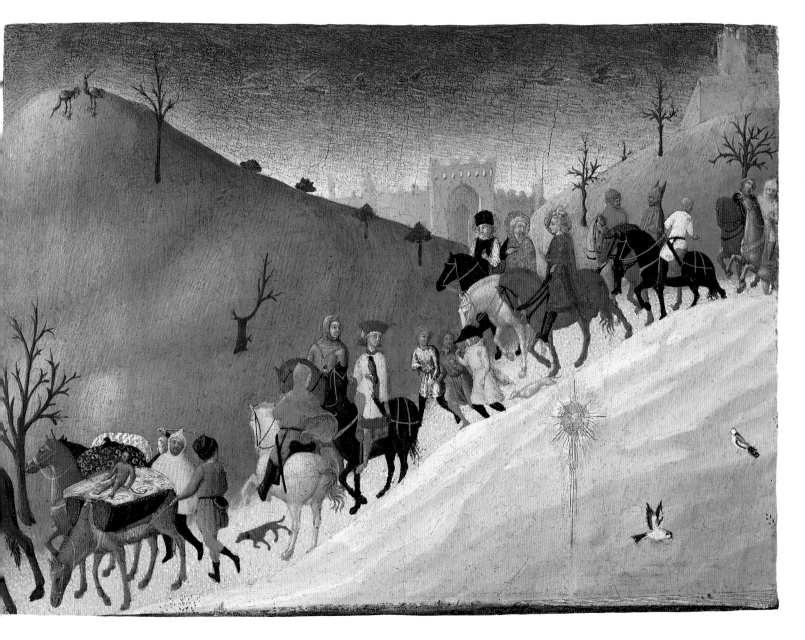

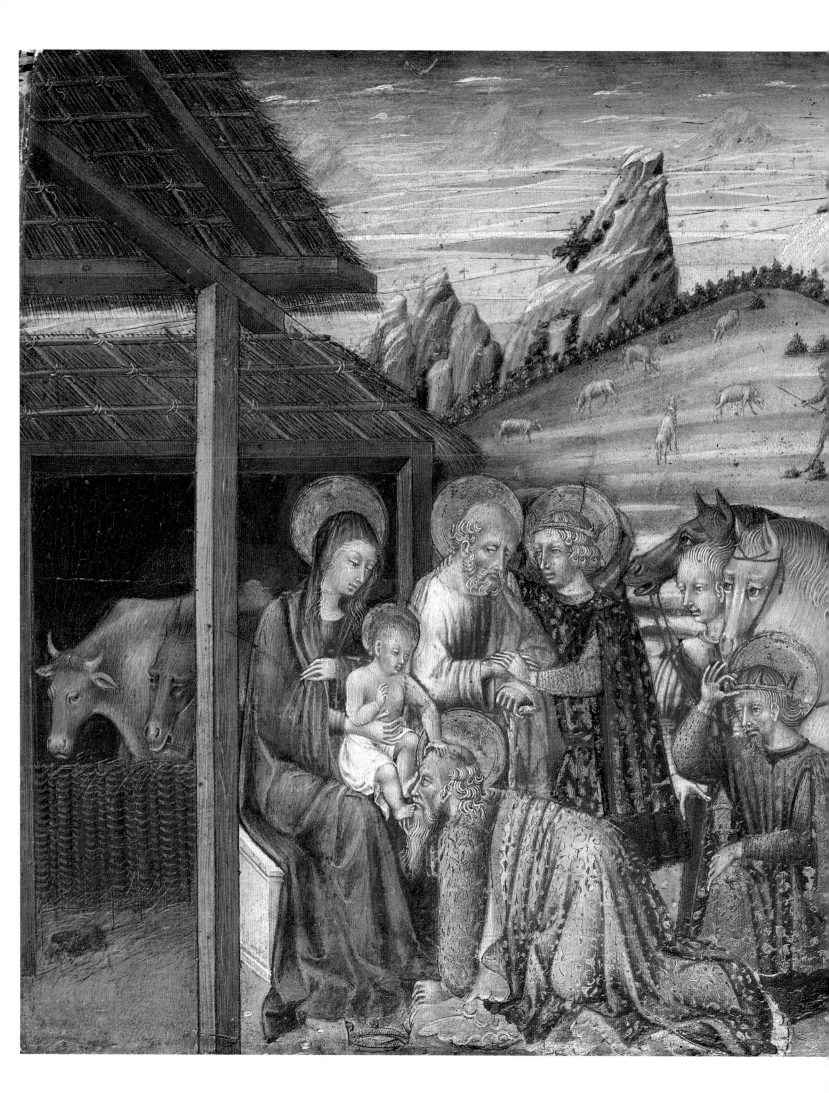

A ND when they were come into the house, they saw the young child with Mary his mother, and fell down, and worshipped him: and when they had opened their treasures, they presented unto him gifts; gold, and frankincense, and myrrh. And being warned of God in a dream that they should not return to Herod, they departed into their own country another way.

THE ADORATION OF THE MAGI
Giovanni di Paolo, Italian (Sienese), active by 1417, d. 1482
Tempera and gold on wood, 10⅝ × 9⅛ in., ca. 1460

Magi is the term usually applied to the exotic trio whose visit to Jesus is illustrated in three paintings in this book. But these interesting fellows are also known in Christian legend as the three Kings. Giovanni di Paolo gives them crowns to indicate their royal status. He also contrasts their finery with the simple garb worn by the Holy Family and the fine steeds the Kings have with the humble ox and donkey that Mary and Joseph use for transportation.

Although Giovanni paints his Kings as quite fancy men, he also depicts them as deeply sincere and humble. The artist lived in Siena, Italy, a city famous for the good manners of its citizens, and he shows the Kings as models of deportment. Two of them take off their crowns and kneel, behavior expected during the Renaissance (even from kings) in the presence of a personage of the highest rank. The third King puts his arm around Joseph's shoulder to congratulate him for having such a fine son, another polite gesture expected from a male guest who comes to see a new baby. But Joseph is distracted. He sees that as the oldest King kisses Jesus, the baby is about to shove his little foot into the King's nose. The King's beard is probably tickling him!

The feast of the Epiphany on January 6 commemorates the visit of the Wise Men to Jesus and is called Three Kings Day throughout Latin America. Traditional Spanish families follow the example of the Magi and exchange gifts then, instead of on Christmas. Giovanni di Paolo shows only one gift instead of the usual three. The Magi, or Wise Men, were the first foreigners to learn about the birth of Jesus, and the celebration of this event is important to Christians because it marks the beginning of the spread of their religion to all the world.

THE ADORATION OF THE MAGI
Quentin Massys, Flemish, 1465/66–1530
Tempera and oil on wood, 40½ × 31½ in.

The townsfolk in the background of this painting may not have known what important neighbors they had until the three Kings arrived. Now that they do, they are full of amazement and wonder. The Kings are filled with different sentiments. The eldest is worshipful, and the others seem to marvel that the king they have searched for is just a little baby.

The Magi thought they would find a real king at the end of their long journey. Quentin Massys does not entirely disappoint them. He invented a richly patterned cloth to hang behind the Virgin and Child. It is based on the "cloth of honor" that was draped above or behind a royal throne. (A cloth of honor was also hung behind a bride and groom at their wedding dinner.) Parts of the interior are also so rich that they suggest a palace. The artist had probably visited Italy, and it was there that he would have found the patterns that decorate the column, its capital, and the crossbeam above.

Quentin Massys heaps such rich apparel onto the shoulders of his Wise Men that they surely look like kings, not philosophers. The one in the front, in fact, has carried a dazzling gold scepter with him on his journey. A symbol of the might of sovereigns, it is resting within easy grasp of the viewer next to the old man's gift to Jesus. The gift is frankincense, and the richly tooled coffer that holds it has been opened so that the baby and his mother can enjoy its exotic aroma. Jesus seems not to notice, however. He is fascinated by the King's long beard and holds two fingers to feel his own chin in a gesture that is also that of a blessing.

At the time this painting was made, Christmas was becoming an important church festival. It had not been celebrated as a separate holiday until the year 336. Before then, the Feast of the Epiphany on January 6 commemorated Jesus's baptism and the visit of the Wise Men, as well as Jesus's birth. Even after December 25 was set aside as the Feast of the Nativity, Epiphany continued to be the more glorious celebration. But the friars of the Franciscan order, which was founded in Italy in the thirteenth century, made Christmas their special holiday. They built small crèches that showed Mary and Joseph at the manger lovingly worshipping the Christ Child, and they even acted out the Nativity events in costumes to make the miracle of Christ's birth more real to devout people.

During Quentin Massys's lifetime, the great German religious reformer Martin Luther borrowed from ancient nature worship, adding the Christmas tree to the celebration of the holy birthday. From the public's enthusiastic response to the new Christmas traditions, artists quickly learned to make the Christmas story as human as possible, and, in time, Christmas became more important than Epiphany.

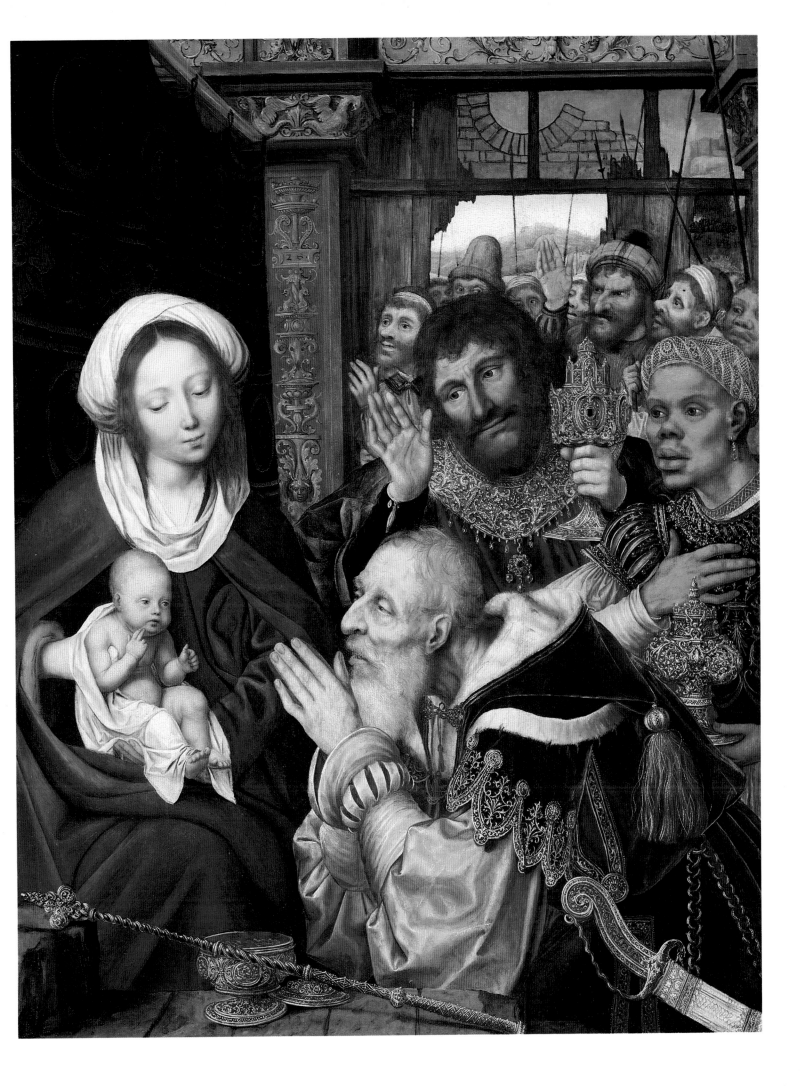

And when they were departed, behold, the angel of the Lord appeareth to Joseph in a dream, saying, Arise, and take the young child and his mother, and flee into Egypt, and be thou there until I bring thee word: for Herod will seek the young child to destroy him. When he arose, he took the young child and his mother by night, and departed into Egypt: And was there until the death of Herod: that it might be fulfilled which was spoken of the Lord by the prophet, saying, Out of Egypt have I called my son. But when Herod was dead, behold, an angel of the Lord appeareth in a dream to Joseph in Egypt, Saying, Arise, and take the young child and his mother, and go into the land of Israel: for they are dead which sought the young child's life. And he arose, and took the young child and his mother, and came into the land of Israel. But when he heard that Archelaus did reign in Judaea in the room of his father Herod, he was afraid to go thither: notwithstanding, being warned of God in a dream, he turned aside into the parts of Galilee: And he came and dwelt in a city called Nazareth: that it might be fulfilled which was spoken by the prophets, He shall be called a Nazarene.

THE FLIGHT INTO EGYPT
Cosimo Tura (Cosimo di Domenico di Bonaventura),
Italian (Ferrarese), active by 1451, d. 1495
Tempera on wood, 15⅝ × 15⅛ in., ca. 1475

Early Christian writers were fascinated that the Holy Family traveled by foot all the way to Egypt, a journey of at least 250 miles, and they invented many tales about occurrences on this arduous trek. By the Middle Ages, these imaginative legends were as popular as the Bible story itself, and many people believed them to be true. The most popular book about the trip and other events in Jesus's infancy was written in the eighth or ninth century and is called the *Gospel of Pseudo Matthew*. Its accounts of miracles performed by the infant Jesus inspired many artists.

Cosimo Tura does not need fantastic episodes for his depiction of the flight into Egypt. Instead, he attempts to give the viewer a feeling of the deep loneliness and desolation Mary and Joseph must have felt as they left their families and friends to protect their son from the wrath of Herod. With an ominous, bloody sky behind them, the family almost seems lost. Mary, quite tired, awkwardly shifts the sleeping Jesus into a more comfortable position. Joseph absentmindedly stares down at their donkey. Having brought the Holy Family from the steep and dangerous road in the background, the animal searches in vain for fodder on the rocky desert floor. As the travelers pause, it appears that the donkey is expected to determine the route. In such straits, a miracle would be welcome!

In Italian, a round painting is called a tondo, and this one was part of a large altarpiece. The artist served the House of Este in Ferrara, one of the most splendid and important courts of Italy, but sadly, very little of his work for those dukes has survived. From this example, it is clear that he was an artist of great originality, capable of expressing deep feeling.

36

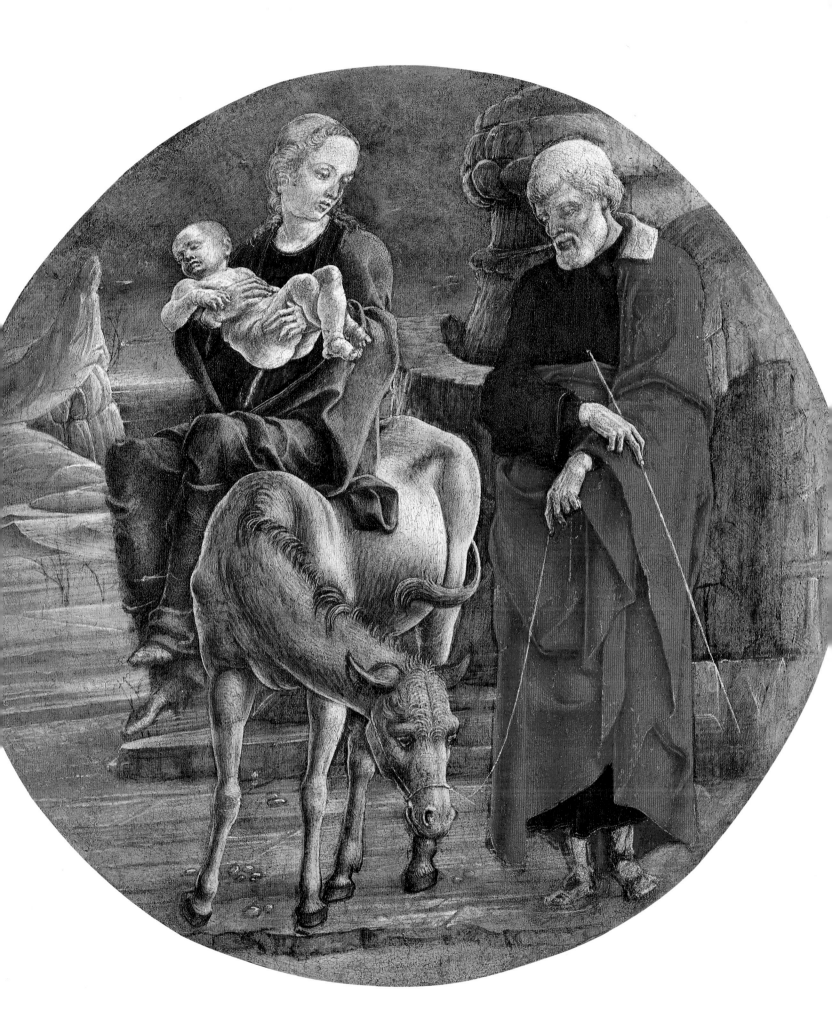

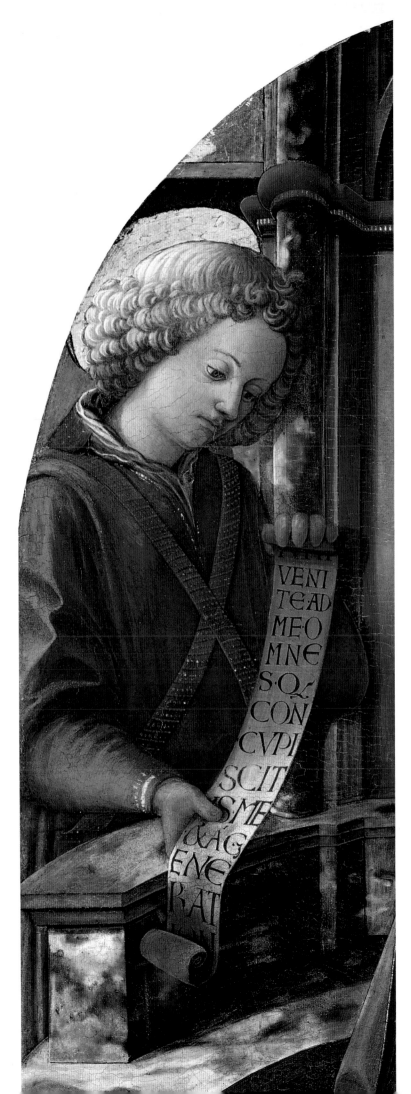

A ND the child grew, and waxed strong in spirit, filled with wisdom: and the grace of God was upon him.

MADONNA AND CHILD ENTHRONED, WITH TWO ANGELS

Fra Filippo Lippi, Italian (Florentine), ca. 1406–1469
Tempera and gold on wood, transferred from wood, 48¼ × 24¾ in.

Christians believed that, from his birth, Jesus was omniscient, a word that comes from the Latin language. (*Omni* means all and *scientia* means knowledge.) To express the idea of an all-knowing person, Fra Filippo Lippi turns to an old tradition in art and has Jesus hold an open book. It represents the wisdom of all the world, future and past. The little boy looks directly at the viewer as though he could already read at the tender age of one or two and can guide the life of anyone who asks for his help. Both he and his mother are somber, for they know that his future will include great suffering. The red flower in Mary's right hand is symbolic of the blood Jesus will shed as he dies on the cross.

Filippo Lippi was an orphan, and perhaps that is the reason he was so fond of painting pictures of the Madonna and Child. He was raised by monks, and next door to their monastery was a church in which the famous artist Masaccio painted murals when Filippo was growing up. Watching him at work inspired Filippo to become an artist himself. He also became a monk for a short time, so his name includes the title Fra, the Italian word for brother, which is what monks call one another.

A sign of great status in this painting is the throne carved from rich marble upon which Mary sits. Its design is based on those used by the emperors of ancient Byzantium, who once ruled all of Italy from their capital in Constantinople. Two angels stand by to attend to the needs of the mother and child. The scroll held by one of them has poetic Old Testament words written on it in Latin. They invite worshipers who contemplate this painting to follow the teachings of Jesus.

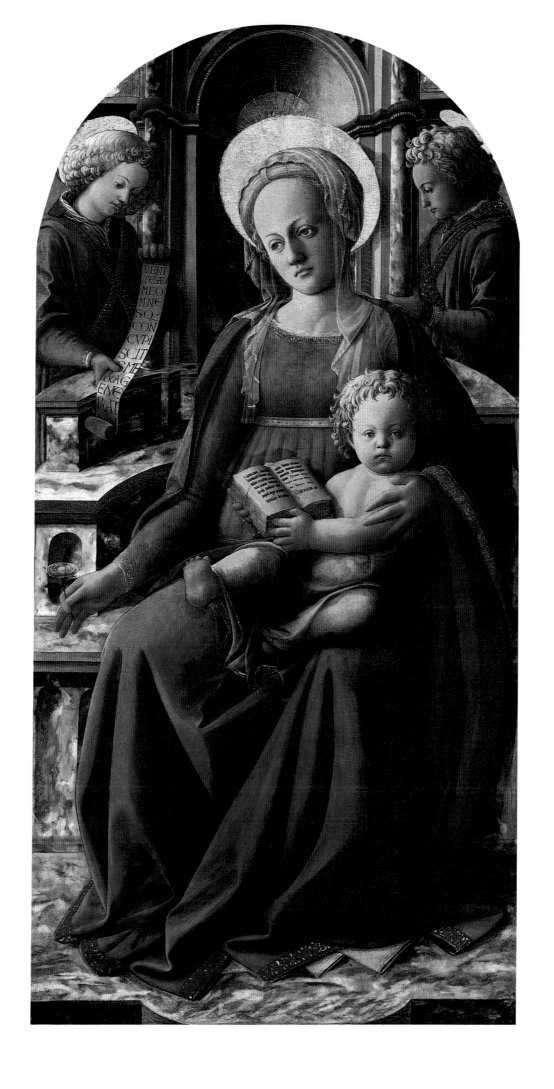

39

CREDITS